LIVES OF IRISH ARTISTS

JACK B YEATS

Jack Butler Yeats
1871–1957

BRIAN P KENNEDY

For Hilary Pyle and Anne Yeats

LIVES OF IRISH ARTISTS

JACK B YEATS

Jack Butler Yeats
1871–1957

BRIAN P KENNEDY

THE NATIONAL GALLERY OF IRELAND

7/98

Produced in 1991 by

Town House

41 Marlborough Road

Donnybrook

Dublin 4

for The National Gallery of Ireland

British Library Cataloguing in Publication Data

Kennedy, Brian P.

Jack Butler Yeats.—(Lives of Irish artists)

1. Ireland. Paintings

I. Title II. National Gallery of Ireland

III. Series 759.2

ISBN: 0-948524-24-3

Cover: *My Beautiful, My Beautiful* (1953)

Title page photo by Adolf Morath

Managing editor: Treasa Coady

Series editor: Brian P Kennedy (NGI)

Text editor: Elaine Campion

Design concept: Q Design

Typeset by Printset & Design Ltd, Dublin

Printed in Italy

CONTENTS

Dr Brian P Kennedy is Assistant Director of the National Gallery of Ireland. His publications include *Alfred Chester Beatty and Ireland 1950–68: A Study in Cultural Politics* (1988) and *Dreams and Responsibilities: The State and the Arts in Independent Ireland* (1990), as well as numerous articles on aspects of Irish cultural history.

7

Jack Butler Yeats is arguably the premier Irish painter of the twentieth century. He has always been highly regarded in Ireland, but his work is insufficiently known abroad. His father, the distinguished portraitist John Butler Yeats (1839–1922), said that one day he would be known as 'the father of a painter' but, in fact, he is most often remembered as the father of a poet, William Butler Yeats (1865–1939).

THE MAKING OF AN ARTIST 9

Although W B was born in Dublin and Jack in London, it was Jack who spent his boyhood years in Ireland. From 1879 to 1887 he lived with his maternal grandparents, the Pollexfens, in County Sligo. His life's work was influenced by his memories of the west of Ireland. 'Sligo was my school', he said, 'and the sky above it'. Life there was full of romance and vivacity. He loved the local characters, the sailors, travellers, tramps, jockeys, actors and circus performers. In 1887 he returned to London to live with his parents at Earl's Court. He found the city exciting for its variety of entertainment; he attended boxing matches, saw Buffalo Bill at the American Exhibition and often visited Sanger's Circus.

Yeats studied at a number of art schools—South Kensington, Chiswick, the West London, and at Westminster under Professor Fred Brown. His father lamented that his son did not take more time to study the human figure and to practise the art of drawing, but, nevertheless,

he remarked shrewdly: 'His personality...has at once the sense of expansion and the instinct of self-control. He has the habits of a man who knows his own mind.' Jack Yeats quickly established himself as an illustrator for various journals and publications. His first cartoon drawing for *Punch* was published in 1896, and he continued to contribute to this humorous periodical until 1941. Few people knew that Yeats was the artist who signed himself W Bird. Yeats's style of drawing was characterised by a strong sense of line, careful composition and conservative colouring. He never kept a diary but, in 1894, he began a life-long system of recording his observations and ideas in little sketch books. These pictorial records provided valuable references which stimulated his imagination. His watercolour *Memory Harbour* (*Pl 1*) is an excellent example of how he could use his recollections to produce a strong visual image. Yeats said: 'No one creates...the artist assembles memories.' He believed that 'the memory side has seldom been developed enough in the teaching of drawing and painting'. 'True painting', Yeats argued, 'is not a trick of juggling; the artist is a person who has developed observation and memory'.

In 1894 Yeats married a fellow art student, Mary Cottenham White, and they settled in her home county of Devon in 1898. The couple had no children, and through fifty-three years of happy marriage 'Cottie' was her husband's most loyal supporter. She was convinced that

he was a man whose genius deserved recognition.

In 1902 Yeats launched a sheet of poems, ballads and illustrations entitled *A Broadsheet*, which was published monthly and of which twenty-four issues appeared. He collected old ballad sheets and illustrated the ballads with vigorous drawings, such as *The County of Mayo (Pl 2)*. *A Broadsheet* was revived in 1908 as *A Broadside*, and for the next seven years Yeats made it a labour of love. His efforts helped to promote and popularise Irish folk culture. Lady Gregory, AE (George Russell), W B Yeats, Padraic Colum and James Stephens were among the many luminaries of the Irish literary renaissance who contributed to these publications. The first poem published in *A Broadside* was by John Masefield, who shared Yeats's interest in miniature theatre, toy ships and literature. Yeats wrote a number of plays for the miniature stage, including *James Flaunty or the Terror of the Western Seas* (1901) and *A Little Fleet* (1903). He published no major works from 1910 through the 1920s, but returned to writing extensively during the 1930s.

A Distinctively Irish Painter

In 1904 the *Art Journal* claimed that of all the artists included in Hugh Lane's exhibition of Irish art at the Guildhall, London, Jack B Yeats was 'the most distinctively Irish painter', his works were 'delightful examples of pictorial Irishism'. It is possible that Yeats had decided early on in his career that he would become *the* Irish painter. He certainly immersed himself in the Irish experience. He remarked: 'We must look to ourselves for the springs of our art...those painters who have the greatest affection for their own country and their own people will paint them best.' Although Yeats knew England well and had travelled to Venice and Northern Italy in 1898, to Paris the following year, and to New York in 1904, his pictorial subject matter was always Irish. He made several visits to Ireland and, in 1905, he toured the poorest districts of the west of the country, providing illustrations for John Millington Synge's articles for the *Manchester Guardian*. Yeats's watercolours, such as *The Man from Aranmore* (Pl 3), provide a visual counterpart to Synge's writings.

It was inevitable that Yeats should want to settle in Ireland. In 1910 he and his wife moved to Greystones in County Wicklow, and in 1917 they moved to Dublin where

cont. p25

ILLUSTRATIONS

PLATE 1

Memory Harbour 1900

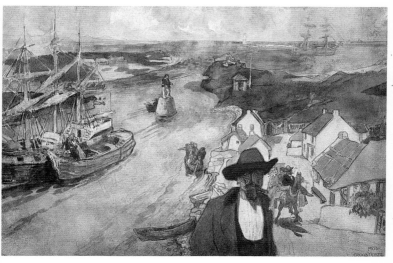

Pl 1 **M**emory Harbour, *Yeats's most important early watercolour, represents an amalgam of remembrances of Rosses Point in Sligo, the county where he spent his boyhood years. The half-length figure in the foreground— an introspective observer—also appears in Yeats's later oil paintings. W B Yeats wrote that his brother's memory 'seems as accurate as the sight of the eye'.*

Watercolour on card; 31 x 47 cm
Private collection

PLATE 2

The County of Mayo 1903

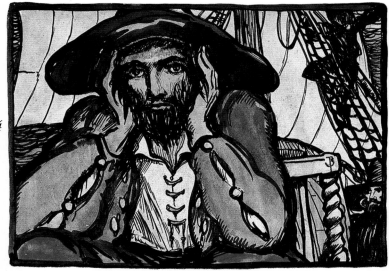

14

Pl 2 This *striking image is from* A Broadsheet, *a sheet of poems, ballads and illustrations produced monthly during 1901 and 1902 by Jack Yeats, with the assistance of American artist Pamela Coleman Smith, to which many luminaries of the literary renaissance contributed.* The County of Mayo *illustrates an Irish ballad which tells of prosperous times in Mayo before Gaelic Ireland was conquered and the poets were obliged to emigrate. Yeats illustrates the sad moment of emigration as the ship sets sail.*

Ink and watercolour on card; 15.6 x 20.2 cm
National Gallery of Ireland

PLATE 3

The Man from Aranmore 1905

15

PLATE 4

Before the Start 1915

16

Pl 3 **I**n *many respects, Jack Yeats provides a visual counterpart to John Millington Synge's writings.* The Man from Aranmore *is proud and determined as he stands on a quayside in Galway, with Aranmore, the largest of the Aran Islands, behind him. Yeats and Synge toured the Gaelic-speaking west of Ireland in 1905. Synge was writing some articles for the* Manchester Guardian *and*

Pl 4

Before the Start *represents the tense, nervous atmosphere of a horse-race as the jockeys are under starter's orders and the crowd waits eagerly for the race to begin. It is a muted but carefully structured and well-balanced picture. Yeats was as yet more interested in forms and masses than in colours. His earliest known oil painting dates from 1902, when he was thirty-one years of age, but, after settling in Ireland in 1910, he began to use oil paints consistently.*

Oil on canvas; 46 x 61 cm
National Gallery of Ireland

17

he asked Yeats to illustrate them. Yeats also illustrated Synge's book The Aran Islands, *and he designed the costumes and set for* The Playboy of the Western World *(1907).*

Chalk and watercolour on Whatman board; 38 x 27.3 cm
National Gallery of Ireland

PLATE 5

The Liffey Swim 1923

18

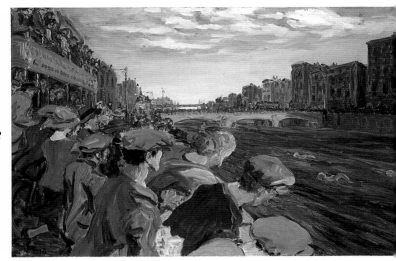

Pl 5 **D**uring the early 1920s Yeats's artistic style wa
undergoing a transition. He told his brother W B: 'I know
I am the first living painter in the world. And the secon
is so far away that I am only able to make him ou
faintly. I have no modesty.' The Liffey Swim is
masterpiece of spectacle and excitement. The paint ha
been worked onto the canvas hurriedly; the artist is i
sympathy with his subject, and vigorous, long brush
strokes full of colour are used to record the flowing rive

Oil on canvas; 61 x 91 cm
National Gallery of Ireland

PLATE 6

A Dusty Rose 1936

Pl 6 **D**uring the 1930s, Yeats painted a series of pictures of roses, blooming, wilting and dying. A Dusty Rose is an attractive, intimate, colour-saturated picture. Yeats wore a single rose in his button-hole at exhibition openings, and tied a paper rose to his easel. He wished to paint sub rosa, that is, he did not wish to explain his pictures. He said: 'If ten people look at my painting and it works for them all in different ways, then it's a good painting.'

19

Oil on canvas; 24 x 36 cm
Private collection

PLATE 7

A Race in Hy Brazil 1937

20

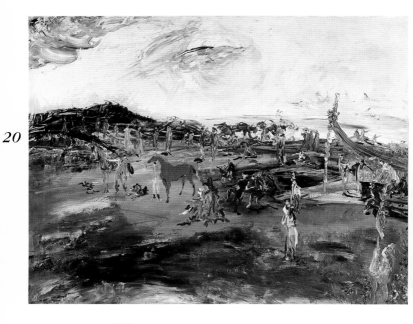

Pl 7 **H**y Brazil, the mythical Isle of the Blest, was said to be off the west coast of Ireland. The painting recalls the horse races Yeats had seen in Sligo, but unlike his early oils, he now represents his horses in an expansive, airy, lyrical and colour-filled landscape. The prow of a ship can be seen on the extreme right. A Race in Hy Brazil reflects Yeats's salutary wish for a land where people would live together in happiness and peace.

Oil on canvas; 71 x 91.5 cm
AIB collection

PLATE 8

Harvest Moon 1946

Pl 8 **D**uring the 1940s, when Yeats was in his seventies, he had a sustained burst of creative activity. Harvest Moon *and other late works are visual poems. Yeats said: 'All painting to be painting must be poetry and all poetry must be painting.' This memorable picture portrays an old pilot in the foreground and two figures in the middle distance, one a young girl, staring intently at the fireball autumn moon. But the translucent figure on the right, melting out of the pilot's body, tells us that the picture is an allegory. The pilot depicted in body and spirit is perhaps contemplating the fruits of his life. It is for each viewer to decide on an interpretation.*

21

Oil on canvas; 61 x 92 cm
Private collection

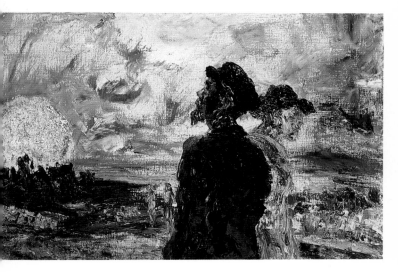

PLATE 9

Grief 1951

22

Pl 9 I*n 1947, after fifty-three years of happy marriage, Yeats's wife 'Cottie' died. In 1949 the last member of his immediate family, his sister Lily, died. He had the company of some devoted friends like Thomas MacGreevy during his final years, but his pictures indicate that he was coming to terms with deep emotions, sadness, loneliness and despair. Yeats was generally optimistic, but in* Grief *he warns of the tragedy of war. Yeats knew*

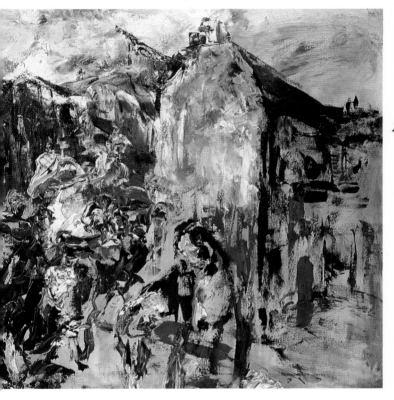

the horror of violence, having lived through the Irish war of independence and the civil war, and two world wars. The paint almost drips off the canvas of Grief, but this is not an abstract picture. Yeats remains figurative in intent even though his lines blur, his forms become indistinct, and his colours explode.

Oil on canvas; 102 x 153 cm
National Gallery of Ireland

PLATE 10

My Beautiful, My Beautiful 1953

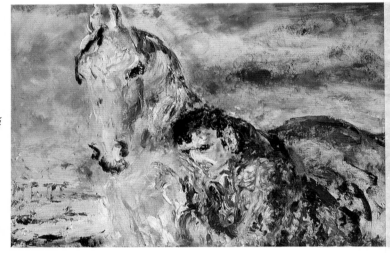

24

Pl 10 The horse was always Yeats's favourite animal, an
his earliest sketches are of horses. For Yeats the
symbolised loyalty, intelligence and freedom. Th
magnificent, noble horse in My Beautiful, My Beautifu
painted when Yeats was eighty-four, is one of his fine
images. It demonstrates his romantic lyricism, h
imagination and vision, and his masterly use of colou
The title of the picture is taken from the first line o
Caroline Norton's poem 'The Arab's Farewell to his Steed'

Oil on canvas; 102 x 153 cm
Private collection

cont. from p12

Yeats lived for the rest of his long life. He was accepted easily by the local artistic community, being elected an Associate of the Royal Hibernian Academy in 1915 and a full member the following year. He liked the vibrant atmosphere of Dublin in the years of the struggle for independence. He was much influenced by the Easter Rising, which confirmed him as a Republican, unlike his brother W B who became a member of the Irish Free State Senate. Although he learned Irish and attended some Sinn Féin meetings, Yeats was not politically active. He painted a small number of subdued pictures on political themes.

'A painter's life', Yeats said, 'is much like the life of anyone who is occupied, ever so little, in using hand, eye, and brain at the same moment, or any way in a chain together'. His career showed a slow but steady progression towards the achievement of his full potential. His style altered gradually from the cool, careful, sombre master of the illustration, to that of a more free-flowing, emotive and intuitive painter. The scale of his works increased in harmony with his expanding vision. He began to look for the universal in the local, much as Joyce was doing with his memories of Dublin. A beguiling draughtsman and sensitive watercolourist, Yeats was liberated by his explorative use of oil paints. His first known oil painting dates from 1902, but after settling in Ireland he began to use oils consistently. *Before the Start* (*Pl 4*) is a typical early oil, cleverly composed but muted in colouring. It was not

until the 1920s that Yeats began to give serious consideration to the artistic power of colours. He remarked: 'I believe that the painter always begins by expressing himself with line—that is, by the most obvious means; then he becomes aware that line, once so necessary, is in fact hemming him in, and as soon as he feels strong enough, he breaks out of its confines.'

26

❧

WORKING METHODS

The Liffey Swim (Pl 5) is a key work of Yeats's transitional phase. He knew it was a successful picture and priced it highly at the Royal Hibernian Academy Exhibition in 1925. It shows clearly that Yeats was now manipulating his paints in an emotive manner. His style became intensely personal. He received no pupils, nobody saw him paint, he did not discuss his technique and was not impressed by continental tuition. His response on hearing that the Irish painters Mainie Jellett and Evie Hone had studied under a French cubist was: 'Who the blazes is Gleizes?' He required peace and quiet in which to work, and even his wife dared not disturb him. He kept his paintings in his studio for six months before releasing them. Each picture was marked

up carefully in his workbook, and when he considered it finished, he drew a little seagull beside the entry to show that his work was ready to fly away.

Yeats had over sixty one-man exhibitions during his lifetime, the first in London in 1897. He also contributed to approximately one hundred and sixty group shows, including the famous New York Armory Show of 1913. But his greatest success came late in life. In 1942 the National Gallery, London, honoured Yeats by hosting a retrospective exhibition of his works alongside one honouring Sir William Nicholson. In 1945 a National Loan Exhibition of 180 paintings by Yeats was held at the National College of Art in Dublin, the first such exhibition ever accorded to a living Irish artist. In 1946 he received an honorary degree from Trinity College Dublin, and the following year he was awarded one by the National University of Ireland. In 1948 there was a large exhibition of Yeats's paintings at the Tate Gallery, London, and in 1951 a retrospective exhibition opened in Washington. He was awarded membership of the Adriatica Cultural Academy, Milan, in 1949, and the next year he became one of the few foreign artists to be invested as an Officer of the Legion of Honour. His first one-man show in Paris opened to great acclaim in 1954.

The reason Yeats won such enthusiastic praise was due to the manner in which his remarkable late work was received. It is indicative that only a few of the works shown

in the 1942 London retrospective exhibition were dated before 1925. Following his change of direction in the 1920s towards a more explorative use of the oil medium, Yeats began to realise his genius. Sir Kenneth Clark explained: '...colour is Yeats's element, in which he dives and splashes with the shameless abandon of a porpoise.' But, he added, it would be a mistake to think that Yeats used colour for its own sake, that is, as decoration: 'He uses it chiefly as a means of expressing the emotion aroused in him by his subjects.' In his late paintings, Yeats often abandoned his paint brush and squeezed his oils directly onto the canvas from the tube. Alternatively, he used a palette knife. On occasions it would appear that he used the pointed wooden end of his brush to stipple the canvas. He also used his thumbs to apply the paints. The great Venetian, Titian, had done this in his very late works where form is subservient to the tremendous power of pure colour.

INFLUENCES

Yeats denied that he had been influenced by other artists. He argued: 'The false picture is most often the picture painted not from Nature but from other

pictures...which perhaps in their turn were painted from other pictures.' He was not much influenced artistically by his father but it is likely that he owed debts to Degas and Sickert. Thomas MacGreevy, poet and director of the National Gallery of Ireland (1950–64), described Yeats as 'standing at the convergence of two tendencies, where an intellectual approach somewhat similar to that of Goya and Daumier met an emotional temper related to Giorgione and Watteau'. These artists may indeed have influenced Yeats but, except for Goya, he refused to admire any of the great artists. Velázquez, Tintoretto and Rembrandt were dismissed as 'journalists'. This may have been bravado, but Yeats *is* a classic individualist. His late style recalls the work of expressionists like Ensor, Munch and Kokoschka, and some of his pictures may be similar to the work of abstract expressionists like Jackson Pollock, but such relationships are coincidental. Yeats was never an abstract artist. His work remains figurative in intent, rooted in daily life and in nature. 'The artist', Yeats considered, 'must always be looking at nature. If he does not, his Art begins to plant a hedge around him'.

JETTISONING MEMORIES

During the 1930s, Yeats produced a stream of novels and plays. He wrote in order to 'jettison his memories'. He later deprecated his literary output when he remarked, 'I wish they'd forget this stuff...they should remember me as a painter'. His writings, nevertheless, are receiving more and more attention. Just as his painting underwent a transformation during the 1920s, his writings too became highly original, enigmatic and fluid. They hold a firm place in European avant-garde literature. Yeats's novels employ the 'stream of consciousness' method, with little emphasis on plot. Yeats read the works of Joyce and thought that Joyce had employed similar techniques to his own. The characters of *The Charmed Life* (1938), Bowsie and Mr No Matter, anticipate Vladimir and Estragon of Beckett's *Waiting for Godot* (1949), but Yeats did not like Beckett's outlook on life and described it as 'amoral'. Yeats's plays, three of which were produced at the Abbey Theatre, are precursors of the Theatre of the Absurd. It is not surprising that both Joyce and Beckett owned paintings by Yeats.

Despite the scale of his literary endeavours in the 1930s, Yeats continued to paint in oils and to draw book illustrations, such as those for Patricia Lynch's much-loved tale *The Turfcutter's Donkey* (1934). Yeats's paintings of this period are very different to his drawings. All are vigorously painted and anti-linear; in conception they are

varied, intimate like *A Dusty Rose* (*Pl 6*), and occasionally panoramic as in *A Race in Hy Brazil* (*Pl 7*). In the latter painting, Yeats creates a wonderful, colour-filled scene using mainly blues, yellows and greens. He was experimenting brilliantly with colours and his themes were becoming more expansive. His pictures often appear to be views of a dream world, hazy, emotional, ethereal. He still employed his stock cast of characters—sailors, actors, clowns, acrobats and gypsies—but they now prompted the viewer to consider why Yeats was choosing to paint them. He had always favoured the colourful characters of a community, the outsiders, the travellers, those who were not part of the settled, humdrum order of life. He also depicted the young and the old, birds and animals, especially donkeys and horses. He idealised female beauty and loved romance. But the theme of sexuality never featured. In that respect Yeats was in sympathy with the ethos of the Irish Free State (1922–49), and he ignored the social realist preoccupations of twentieth-century European expressionists. It is peculiar, however, that except for a few isolated works, Yeats failed to represent religious practice, a dominant feature of Irish cultural life. Whether it was because he lived in a self-consciously Catholic country, or due to his Protestant background, or his free-thinking father, Yeats in his writings and his paintings is a convinced humanist who never preaches.

31

SIGNPOSTS TO MEANING

It is unhelpful to search too deeply for meaning in Yeats's late paintings. They should be enjoyed, first and foremost, for their visual and aesthetic qualities. Many of the pictures have literary titles which can act as explanatory signposts. But Yeats disliked those who would over-analyse his work. He made the point clearly in *The Green Wave*, a conversational piece written as a prologue to his play *In Sand*. Two elderly gentlemen contemplate a painting and one asks the other: 'What is it?' 'It's a wave.' 'I know that, but what sort of wave?' 'A green wave—well—a rather green wave.' 'What does it mean?' 'I think it means just to be a wave.' A picture like *Harvest Moon (Pl 8)* can be interpreted in different ways, but above all else it is a memorable and haunting image.

From about 1940 until he ceased painting in 1955 at the age of eighty-four, Yeats worked incessantly, producing pictures of strong vitality and visual power. During the 1940s he produced up to one hundred paintings per year, an extraordinary output. His ideas did not always work on canvas, so the quality is not even. Some of his pictures are also technically deficient. They have suffered cracking and loss of paint due to inadequate priming and excessive use of oil in the paints. For a short time after his wife's death in 1947, Yeats could not bring himself to paint, and his friends feared that he would not do so again. Gradually

he exorcised his pain and loneliness by completing a number of emotive pictures. Then he resumed his attempts to illustrate so many of his assembled memories. He explained his motivation: 'The true artist has painted the picture because he wishes to hold again for his pleasure—and for always—a moment, and because he is impelled by his human affections to pass on the moment to his fellows and to those who come after him.'

33

Yeats's last pictures, painted when he was in his eighties, are among his best. In *Grief* (*Pl 9*), a wild and tragic picture protesting against the horror of war, the paint seems to drip down the canvas, blood-like, as a mass fight takes place before a gesticulating figure on a white horse. The paint is thin and grainy on the flat areas, excepting those which Yeats has dared to leave blank, and in other parts of the picture there is thick impasto, heaving off the canvas in peaks of pure colour. Yeats said: 'When I begin a painting I think I'm in control, but after a while the paint controls me, and as I go on, we work together...the title comes later.' This does not mean that Yeats began a picture without a subject in his mind; it is his way of explaining the power which compelled him to paint. By the time he ceased painting, he had completed 1200 oil paintings and 700 drawings. In his final paintings, Yeats realised his ambition to paint as he saw fit, without constraint or limitation. The magnificent head of the horse in *My Beautiful, My Beautiful* (*Pl 10*) is characterised with ease;

the rich strokes of paint appear casual, but are the inspired results of long experience.

৵

THE IMPORTANCE OF JACK B YEATS

Jack B Yeats died on 28 March 1957 and was buried at Mount Jerome Cemetery, Dublin. Thomas MacGreevy wrote that Yeats became *'the* national painter…the painter who in his work was the consummate expression of the spirit of his own nation at one of the supreme points in its evolution'. While there was much truth in this assertion, Samuel Beckett cautioned: 'The national aspects of Mr Yeats's genius have, I think, been over-stated… To admire painting on other than aesthetic grounds, or a painter, *qua* painter, for any other reason than that he is a good painter, may seem to some uncalled for'. In Beckett's opinion, Yeats 'is with the great of our time…he brings light, as only the great dare to bring light, to the issueless predicament of existence'. Yeats was not one of the mould-makers of twentieth-century art, like Kandinsky or Picasso. But he was a great painter who in his late works developed an Irish romantic expressionism which helped to educate his

audience to appreciate a lyrical, imaginative and painterly approach to the making of pictures. Just as Irish writers must cope with the influence of Joyce, Irish painters cannot avoid the impact of Yeats. There is now emerging international recognition for his work. Yeats left his legacy of visual poems and then dismissed himself: 'A picture does not need translation. A creative work happens. It does not need documentary evidence, dates, photographs of the artist, or what he says about his pictures. It doesn't matter who or what I am. People may think what they will of the pictures.'